ESSENTIAL GUIDE TO
DRAWING
Life Drawing

ESSENTIAL GUIDE TO
DRAWING
Life Drawing
A PRACTICAL AND INSPIRATIONAL WORKBOOK

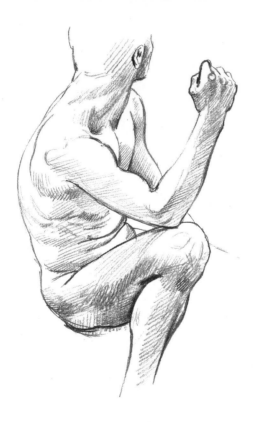

BARRINGTON BARBER

ARCTURUS

ARCTURUS

This edition published in 2012 by Arcturus Publishing Limited
26/27 Bickels Yard, 151–153 Bermondsey Street,
London SE1 3HA

ISBN: 978-1-84858-811-0
AD002355EN

Printed in Singapore

CONTENTS

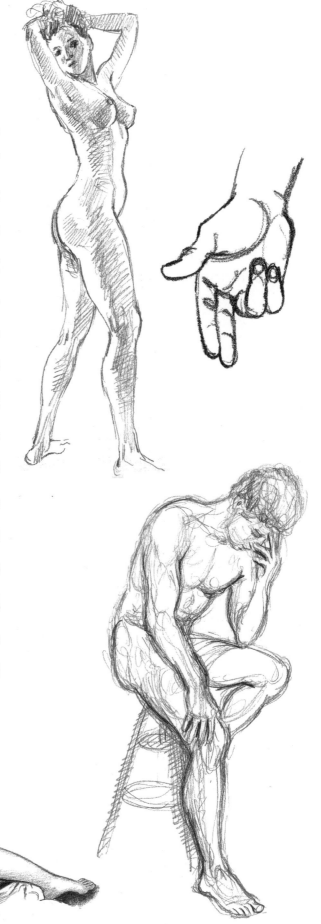

///// Introduction

The human figure is both the hardest and yet most satisfying subject to draw and no artist ever really exhausts its possibilities. However, if you are trying to teach yourself, discipline and an eye for detail will take you a long way. The best way to start is by observing people carefully: the way they move, sit and stand and how they look in different lights and from different angles. The great figurative artists studied the human form for their entire lives without reaching a limit with it, so there's plenty of scope!

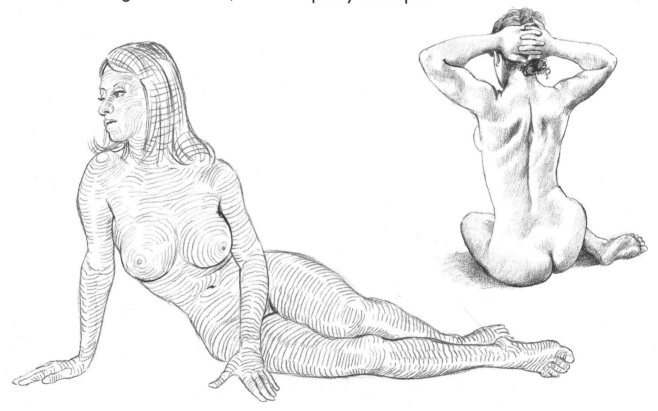

Being a human oneself loads the artist with all kinds of preconceptions, which can make it very difficult to see a way through to making the first marks on paper. However, some elementary knowledge of anatomy is ours already: we know generally how we are put together; how to move various parts of ourselves; and we know the difference between feeling tense and relaxed. With observation, practice and concentration,

we are only a short distance from translating this knowledge into line and tone.

It is good to study the various styles and techniques of other artists but there is no substitute for your own response to something as infinitely fascinating as the human figure. Life drawing is the best way to learn how to do this, and in this book we look at how you can make the most of the experience of drawing the human figure directly.

Any medium is valid for drawing figures from life and I have shown a range of possibilities here and later in the book. You probably don't need to buy all the items listed below, and it is wise to experiment gradually. Start with the range of pencils suggested, and when you feel you would like to try something different, do so. For paper, I suggest starting with a medium-weight cartridge paper.

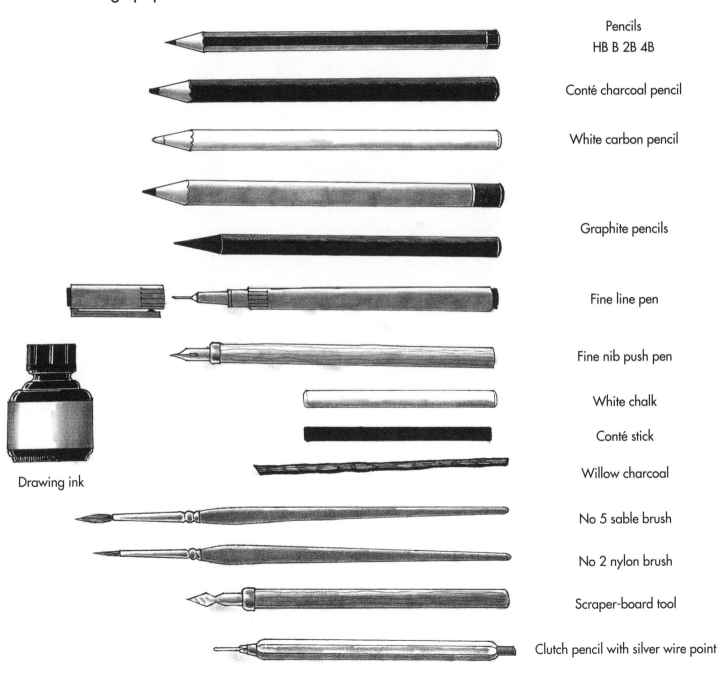

Pencils
HB B 2B 4B

Conté charcoal pencil

White carbon pencil

Graphite pencils

Fine line pen

Fine nib push pen

White chalk

Conté stick

Willow charcoal

Drawing ink

No 5 sable brush

No 2 nylon brush

Scraper-board tool

Clutch pencil with silver wire point

Life Drawing Classes

The human body is a most subtle and difficult thing to draw and you will learn more from a few lessons in front of a nude model than you ever could when drawing from photographs.

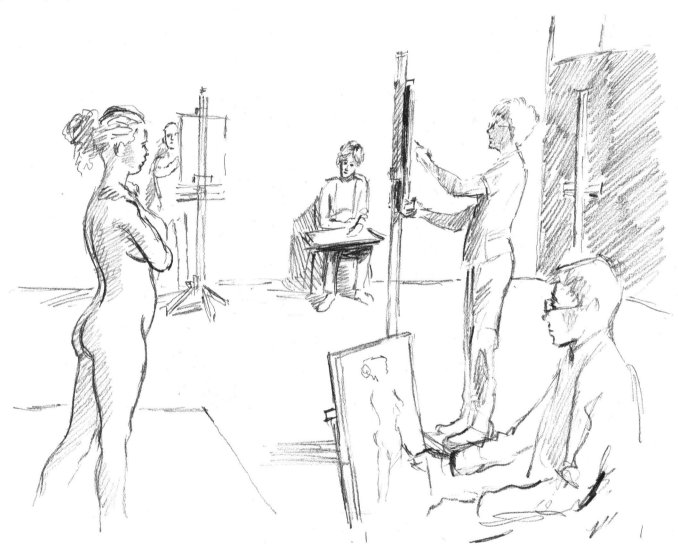

In most urban areas, life classes are not too difficult to come by and if there is an adult education college or an art school that offers part-time courses it would be an excellent way in which to improve your drawing. Even professional artists will attend life classes whenever possible, unless they can afford their own models. These classes are however limited to people over the age of 16 because of the presence of a nude model. One advantage is that there is usually a highly qualified artist teaching the course. The dedication and helpfulness of most of these teachers will enable you to gradually improve your drawing step by step, and the additional advantage of working with other students, from beginners to quite skilful practitioners, will encourage your work.

Working at a board or easel

If you don't have an easel and are sitting with the board propped up, the pencil should be at about shoulder height and you should have a clear view of the drawing area.

The best way to draw is standing up, but you will need an easel for this.

There should be plenty of distance between you and the drawing. This allows the arm, wrist and hand to move freely and gives you a clearer view of what you are doing. Step back every few minutes so you can see the drawing more objectively.

Keep your grip easy and don't be afraid to adjust it. Don't have a fixed way of drawing.

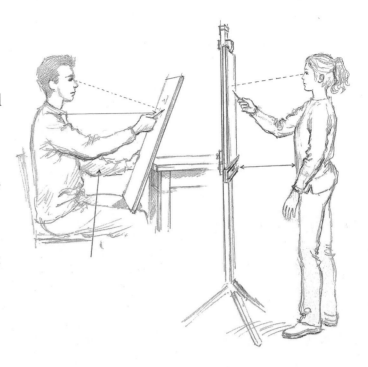

Using the paper

Try to work as large as possible from the beginning. The larger you draw the easier it is to correct. Aim to gradually increase the size of your drawing until you are working on an A2 sheet of paper and can fill it with one drawing.

You will have to invest in an A2 drawing board for working with A2 paper. You can either buy one or make one out of quarter-inch thick MDF. Any surface will do, so long as it is smooth under the paper; masking tape, paper clips or Blu-Tack can be used to secure the paper to the board.

Holding the pencil

Your inclination will probably be to hold the pencil like a pen. Try holding it like a brush or a stick. Keep the grip loose. You will produce better marks on the paper if your grip is relaxed and there is no tension in your hand or arm.

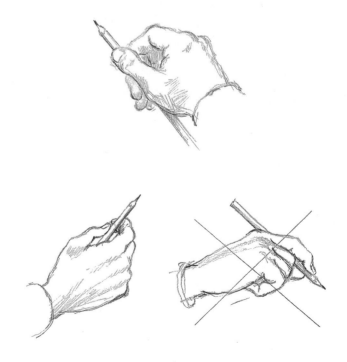

Drawing the Whole Figure

As we have seen, drawing the complete human body is really the subject of a life class. Generally speaking, the best you may be able to coax from friends and family is posing clothed or in a bathing costume. This is sufficient for a general view of the body, but to study it more closely in order to understand the bones and muscles showing on the surface, a tutored course in life drawing is the obvious answer.

A standing position with no foreshortening is easiest, but you will also need to draw models sitting, reclining and in various more complex poses where the limbs and torso are turned, folded and twisted to show how the different parts of the structure function together. Try to draw from models of different shapes, sizes and ages where possible. One good way to gain an understanding of the structure of the body is to have the model sitting on a revolving chair and gradually turn it around so that you are drawing the figure in the same pose from a variety of positions.

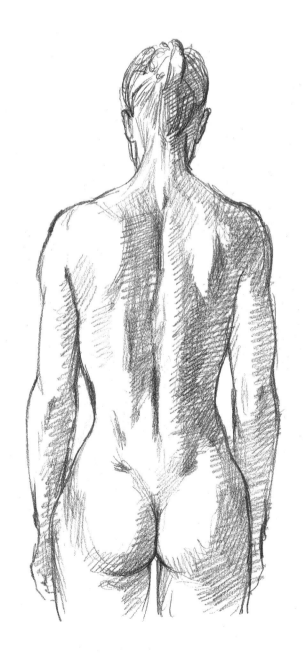

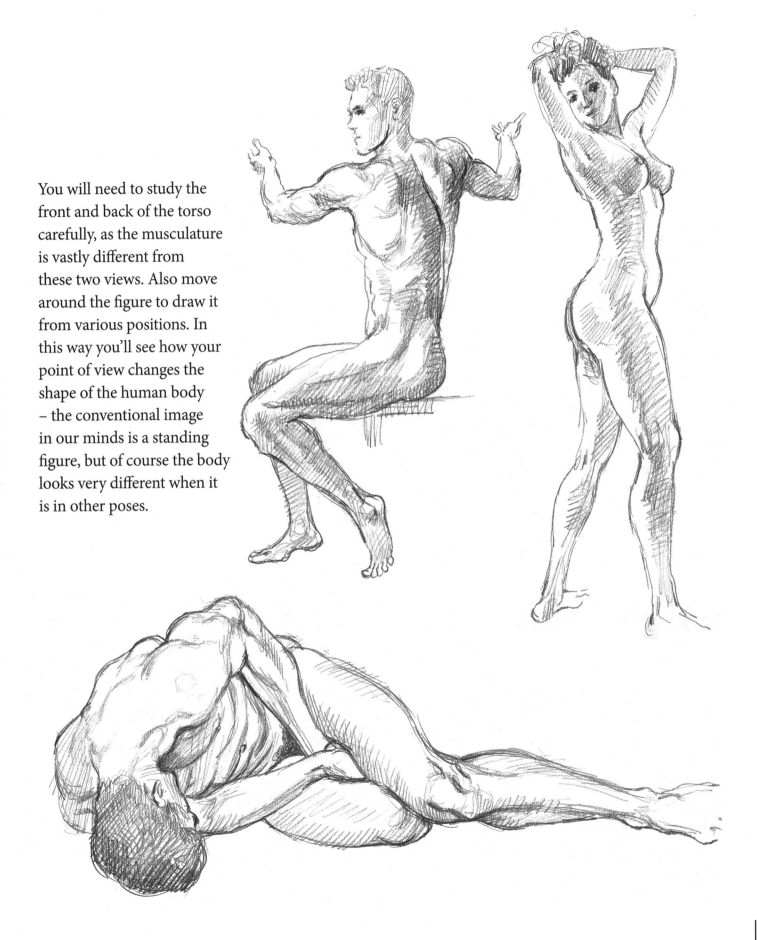

You will need to study the front and back of the torso carefully, as the musculature is vastly different from these two views. Also move around the figure to draw it from various positions. In this way you'll see how your point of view changes the shape of the human body – the conventional image in our minds is a standing figure, but of course the body looks very different when it is in other poses.

Proportions of the Body

Familiarity with the proportions of the body will help you to make your drawings more convincing. Here we look at four versions of the human body standing upright: a male full front and side views and a female and a child full front view.

Front and side view of the body

If you take the length of the head as the unit of measurement, the whole length of the body is equivalent to about seven and a half heads. This is true of both male and female bodies – although the female is usually slightly smaller, the proportions remain the same.

The level of the nipples is about two units down from the top of the head, while the navel is three units down. The top of the legs is about four units down; the length of the arms and hands, with the fingers extended, comes down four and a half units, to the middle of the thigh. The bottom of the kneebone appears about five and a half units down from the top.

The main difference in proportion between the male and female comes in the width of the hips and the shoulders. The shoulders are usually the widest part of a man's body while the hips tend to be the widest part of a woman's.

These proportions act as guidelines when you are drawing the human form, but even so nothing beats careful observation. Remember too that people differ in the bulk of flesh and muscle, and although the female form is usually rounder and smoother you may find exceptions. However, these proportions apply to almost all people of adult years. Children, of course, are of different proportions at different ages.

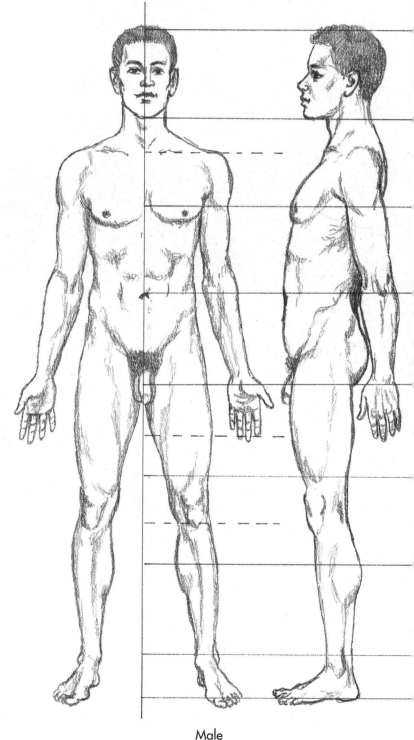

Male

Male and female: proportions the same
although heights may be different

HEAD UNIT

Top of head	0
Chin	1
Shoulder line	
Nipples	2
Navel	3
Pubis	4
Length of arm and hand	
Above knee	5
Bottom of kneebone	
Mid-calf	6
Ankles	7
	7½

Female

A child's head is much bigger in
proportion to the body. At 1 year
old it is about 3 to 1 and as they
grow the proportions gradually
approach those of an adult. At
about 9 or 10 years old, a child
will be about 6 units or heads to
the full height.

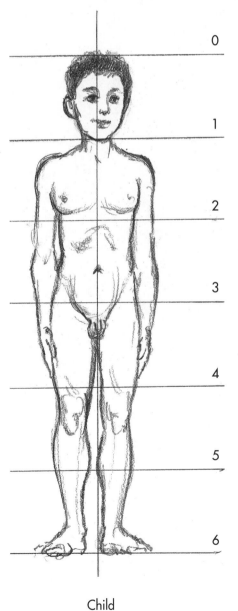

0
1
2
3
4
5
6

Child

//// Odd Proportions

The importance of correctly relating proportions within the human figure becomes very apparent when you have a figure in which some parts are foreshortened and others are not.

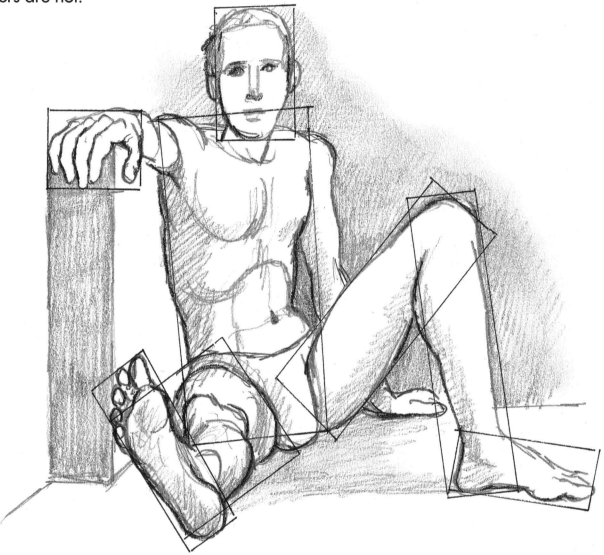

In this example you'll notice that the right leg and arm are pointing towards the viewer, whereas the left leg and arm are not. As a result, the area taken up by the respective legs and arms is quite different in both proportion and shape. The right arm is practically all hand and shoulder and doesn't have the length evident with the left arm. The right leg is almost a square shape and strikingly different from the long rectangles of the left leg. The rectangles about the head and torso are also interestingly compared with the different arms and legs.

Once you begin to see such proportional differences within a subject, you will find your drawing of the whole becomes easier.

Vive la différence

People come in all shapes and sizes and it is best to practise drawing as many differing body forms as you can. The examples shown here are of the same height (about seven heads high) and vertical proportion but vastly different in width. If presented to the inexperienced artist in a life class, both would be problematical, because beginners tend to draw what they think people should look like, and will even out oddities to fit their preconceptions. Often they will slim down a fat model or fatten up a thin one. If they themselves are slim, they will draw the model slimmer than they are. Conversely, if they are on the solid side, they will add flesh to the model. In effect they are drawing what they know, not what they see. This doesn't result in accurate draughtsmanship and has to be eliminated if progress is to be made. Remember: horizontal proportions are measured in exactly the same way as vertical proportions.

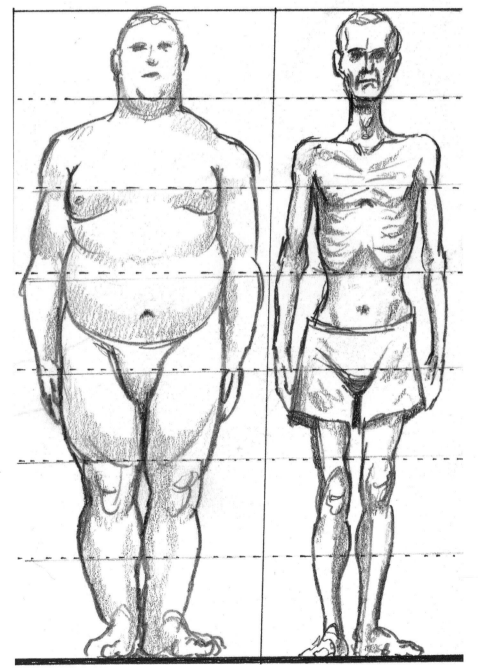

The Body in Perspective

Quite often, the model will be lying down in a position that shows either their head or their feet receding from your point of view. This means that the proportions of the body will not be those with which you are most familiar, and it is helpful to pause and analyse what it is you are actually able to see.

In these two diagrams, you are shown one body from the foot end and one from the head end. The grid patterns clarify what is happening to the shape and proportion of the body.

Both drawings, based on paintings by Lucian Freud (1922–2011), graphically illustrate the effect of perspective on the relative sizes of different parts of the body. In the drawing below (*Naked Girl Asleep II* 1968), notice how much larger the legs and feet are in relation to the torso and head area. Note also the diminishing width of the figure as it recedes from the viewer.

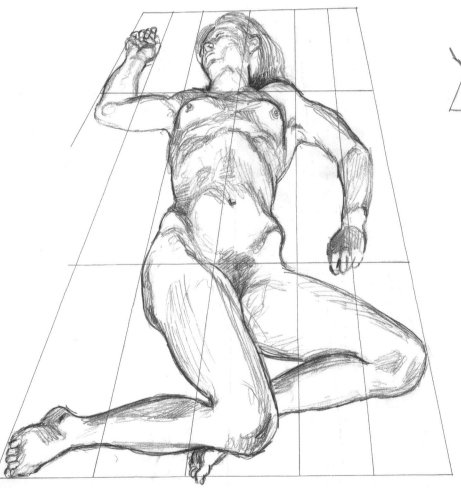

In the second drawing (*Night Portrait, Face Down* 1999), the area of the head and shoulders is far larger than you may have expected and the legs and feet are much smaller. Again, the diminishing width is giving a clear indication of the effect of perspective.

When the body is foreshortened, what is nearest to us appears to be proportionally larger than what is further away. The actual relative sizes of parts of the body are meaningless. What determines this relative size in art is the view or perspective from which they are seen.

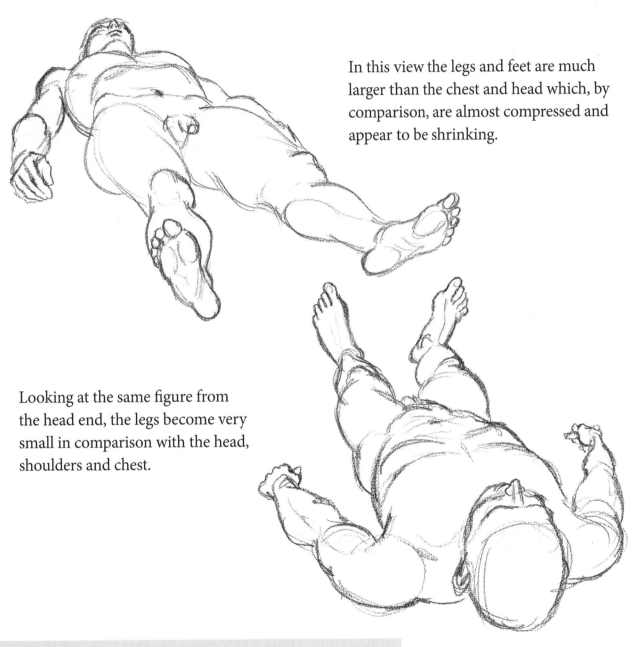

In this view the legs and feet are much larger than the chest and head which, by comparison, are almost compressed and appear to be shrinking.

Looking at the same figure from the head end, the legs become very small in comparison with the head, shoulders and chest.

Learning to draw the human figure from all angles is complex and time-consuming. Don't expect to see a dramatic improvement in your skill unless you practise at least once a week.

More Foreshortened Figures

The next drawings also look at figures which are lying and sitting in such a way that some of their limbs are foreshortened. You will have to look carefully at how the proportions of the limbs differ from how they would appear if the same figures were standing up.

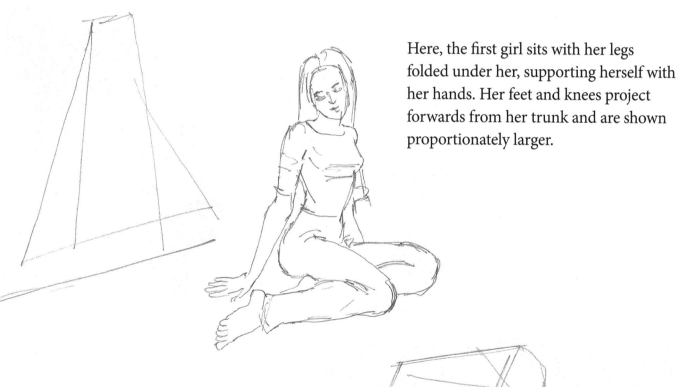

Here, the first girl sits with her legs folded under her, supporting herself with her hands. Her feet and knees project forwards from her trunk and are shown proportionately larger.

The girl lying down holding her knees creates the problem of working out the proportion of both the arms and legs because of the angle from which we see them. In the case of the girl lying down with her head towards us, the legs appear much shorter and the head correspondingly larger than we tend to expect. Expectations are always a distraction in art, and it's better to try to reject them. Instead, remember to observe closely and draw what you actually see, not your assumptions about a subject.

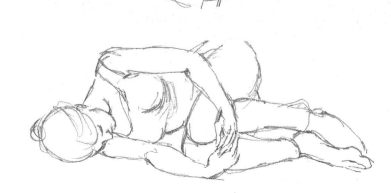

Finally we have three male figures in poses where the foreshortening of the limbs is to be observed as you draw them. When you ask your friends or family to pose for you, make sure that sometimes they sit with their limbs advancing or receding to create this opportunity for you to draw in perspective.

The first figure, sitting on a stool, is relatively straightforward where the legs are concerned, but the folded arms pose a foreshortening problem.

The figure of a kneeling man poses problems both with the arms and the legs, so observe them carefully if you try this pose. These drawings are more useful if done from real people posing for you; if you can't get enough patient models, use photographs – but take them yourself. As before, don't forget to block the pose in before you try to put in all the details.

The lying man is seen almost from above, so that the arm he is resting on half disappears, and one bent lower-leg is almost hidden from our sight.

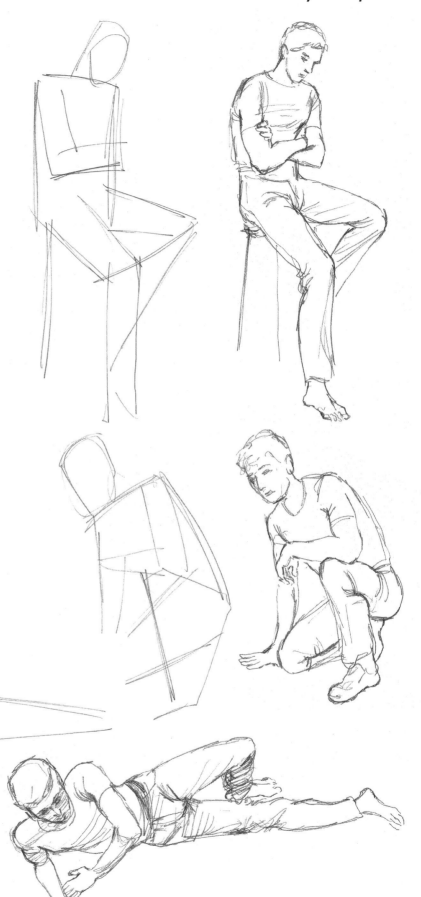

Basic Stages of Drawing a Figure

When you come to draw a human figure from life, it's a good idea to simplify it at first. To start with, try blocking in the main shapes without any detail and then work on from that point.

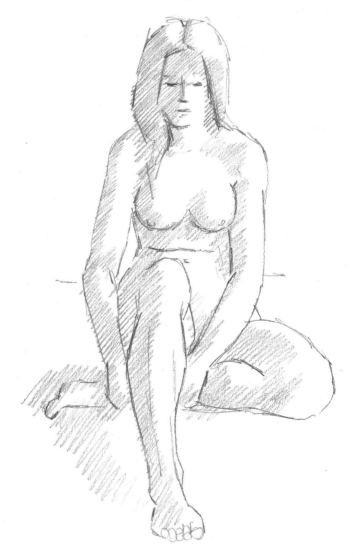

1. Here is a female model, sitting with one leg tucked under the other. Studying the principal features, the outline of the figure can be clearly defined by the arms, legs, torso and head, put in without any detail. Before the next stage, all proportions should be checked and the rest of the drawing should not be advanced until you are sure that the main shapes are in the correct relationship to one another.

2. Move on to adding a bit more detail, such as the features of the face, the feet and hands. Then put in the shading, in a very basic form. Use one simple half-tone for all the shadow that you can see, whether dark or light. At this stage, this is all you need, to indicate the solidity of the figure.

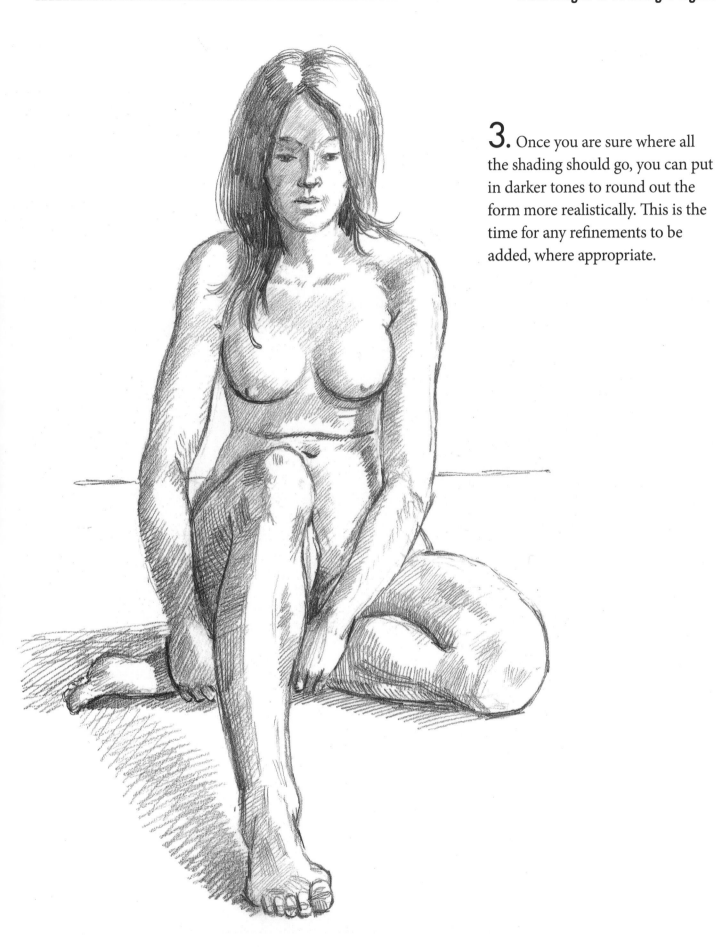

3. Once you are sure where all the shading should go, you can put in darker tones to round out the form more realistically. This is the time for any refinements to be added, where appropriate.

Describing Form

One of the greatest problems with life drawing is the need to indicate the three-dimensional qualities of the figure, so that the eye is convinced that what it is seeing has mass and volume. Here are some examples of different approaches.

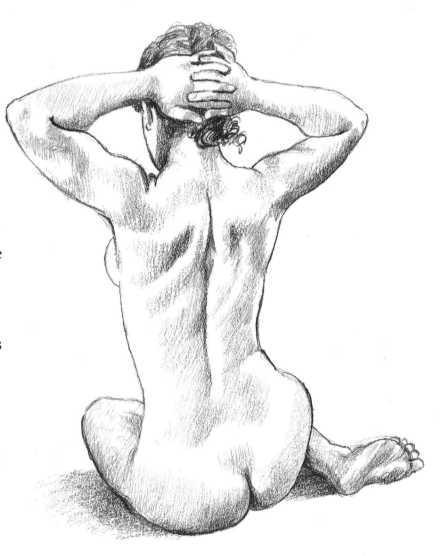

The first example shows the classic method of shading in pencil, which the majority of artists use at some time or another, and it is probably one of the most effective methods of showing solidity. What artists rely upon here is the fact that we cannot see anything without sufficient light both to illuminate one surface and throw another into the shade. Traditionally, the way to illustrate light and shade is to move your pencil across the paper in regular, close-set lines to effect an area of shadow. This has to be done in a fairly controlled way and the better you become at it, the more convincing is the result. Leonardo da Vinci (1452–1519) was famous for laying on shadow in this way, using a technique called *sfumato*, meaning that the result was so subtle and soft that the gradation of tone looked almost like smoke. Our example doesn't claim to be as expert as Leonardo's, nevertheless you can see how by very careful progression with the shading, the impression of a solid body with the light falling on it from one side is convincing, and gives roundness to the limbs and torso of the model.

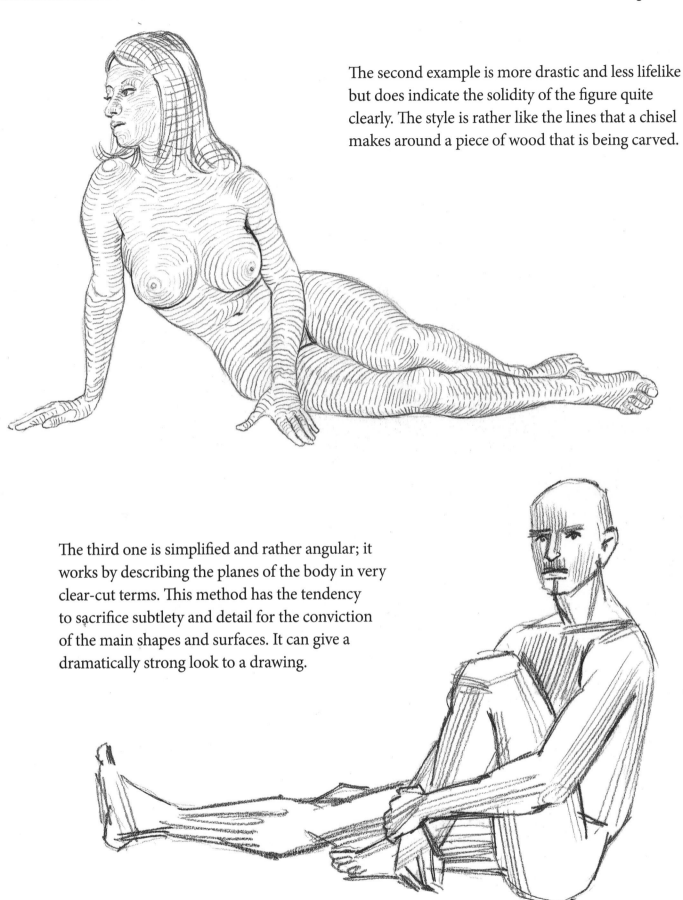

The second example is more drastic and less lifelike but does indicate the solidity of the figure quite clearly. The style is rather like the lines that a chisel makes around a piece of wood that is being carved.

The third one is simplified and rather angular; it works by describing the planes of the body in very clear-cut terms. This method has the tendency to sacrifice subtlety and detail for the conviction of the main shapes and surfaces. It can give a dramatically strong look to a drawing.

Other Forms

Here are some more examples of the varied ways in which the three-dimensional human form can be described, including examples by master artists.

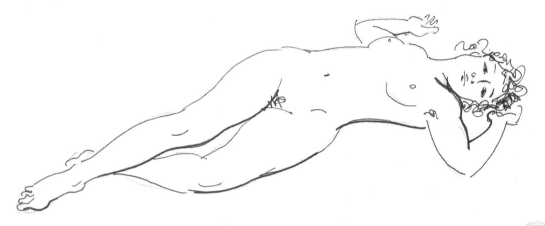

This method attempts to describe form purely by using an outline. To someone truly interested in art, this approach can be most rewarding because it enables the eye to read into the picture a great deal that is only hinted at. In the hands of a master like Matisse, for example, the impact is extraordinary because there seems to be solidity and depth without any obvious way of showing it.

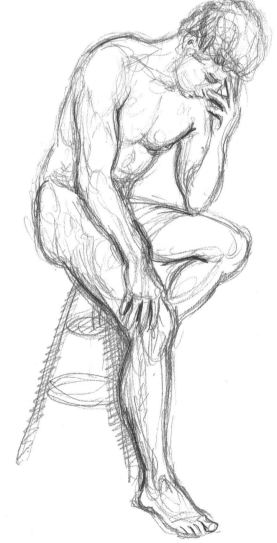

This next drawing is similar in style to the first but shows more of an exploration by the artist of where the final lines might be. This technique is the expression of an ongoing process. All the lines suggest the limits of the figure without actually defining it, leaving the viewer with the idea that there was another possibility that might have been drawn if the artist had had the time.

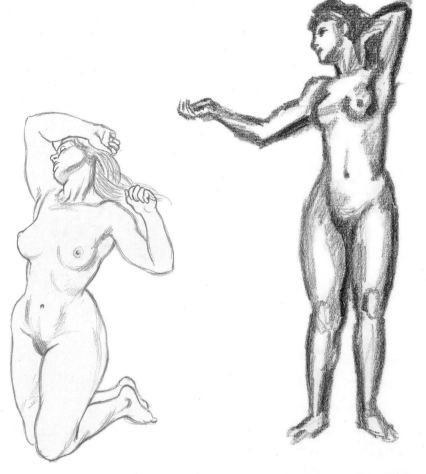

The work of Franz Stuck (1863–1928) is linear in style; the bulk of the form is realized with few lines, allowing our minds to fill in the empty spaces with the fullness of the flesh.

This example, also a copy of a Stuck, is more dramatically drawn. Although the edges are soft there is a powerful fullness of form, with chalky-looking tonal marks indicating the roundness of the body.

The approach of Otto Greiner (1869–1916) to form is essentially that of the classical artist, as this copy shows, with the light and shade carefully and sensitively handled. It's an effective if slow and painstaking method, but well worth mastering. Notice how some lines on the drawing follow the contours around the form and sometimes go across it.

////// Analysing Balance and Pose

The figures in this section demonstrate how to observe the human form and to analyse what is happening to the placing of the body as you draw it.

Start off by visualizing a line from the top of the head to the point between the feet where the weight of the body is resting – this is its centre of gravity. Our system labels this line (from head to ground) as line A.

Next, take the lines across the body that denote the shoulders, hips, knees and feet. The way that these lines lend balance to the form tells you a lot about how to compose the figure. The system labels these as follows: the shoulders, line B; hips, line C; knees, line D; feet, line E. Then, note the relationship between the elbows and the hands, although these are not always so easy to see. The system here is: the elbows, line F; hands, line G.

So now, as you glance down the length of the figure, your eye automatically notes the distribution of these points of balance. Concentrating your observations in this way, you will find it much easier to render the figure realistically.

The first figure is standing and the distribution of the various levels of balance can be seen quite clearly. The only one that is a bit difficult to relate to is line F, linking the two elbows.

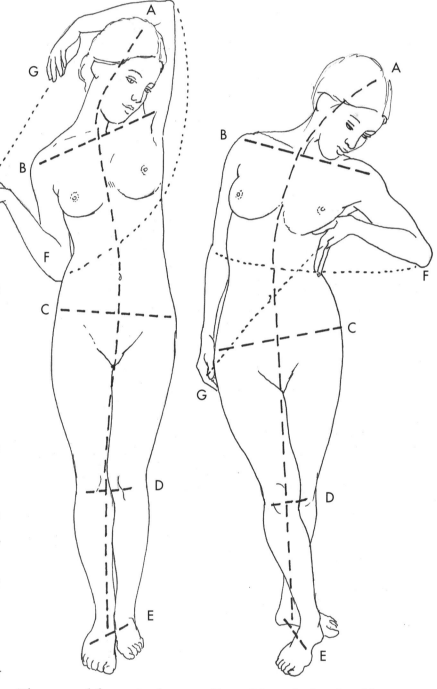

The second figure is also standing, although the shoulders and hips are different from the first. Nevertheless, it is still fairly easy to see how the points relate to one another.

The third figure, still standing but sideways-on this time, makes some of the balancing points less significant. The hips, for example, are one behind the other so they don't register much. The hands are together, so that simplifies that aspect. But the remaining points are important to observe, to give the right kind of balance to the figure.

This standing figure uses all of the points, except for the hands and the knees, which are one behind the other in both cases.

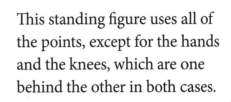

Now, we have a sitting figure in which the main line, A, is shortened to cover the upper part of the body only, because this is where the balancing line stops. However, the rest are obvious enough, although the lines connecting hands and elbows actually cut across each other in this pose.

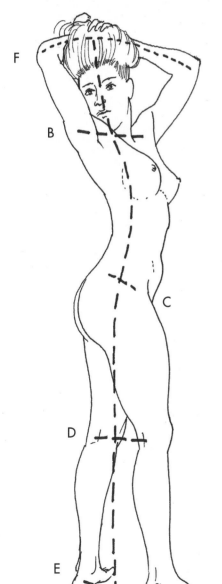

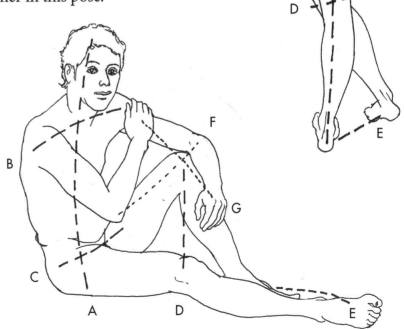

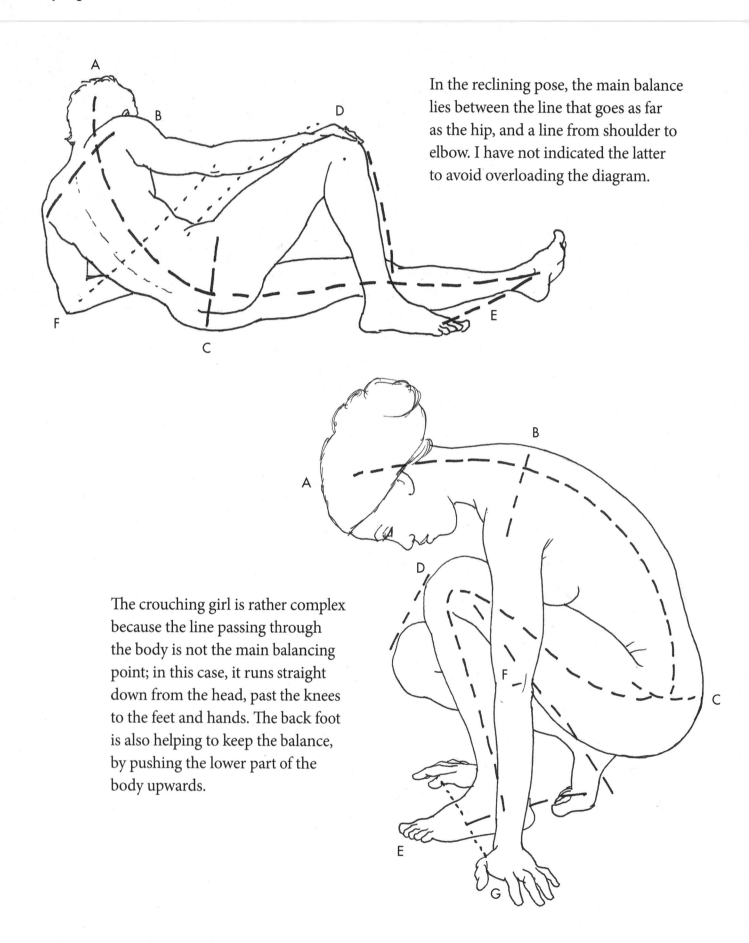

In the reclining pose, the main balance lies between the line that goes as far as the hip, and a line from shoulder to elbow. I have not indicated the latter to avoid overloading the diagram.

The crouching girl is rather complex because the line passing through the body is not the main balancing point; in this case, it runs straight down from the head, past the knees to the feet and hands. The back foot is also helping to keep the balance, by pushing the lower part of the body upwards.

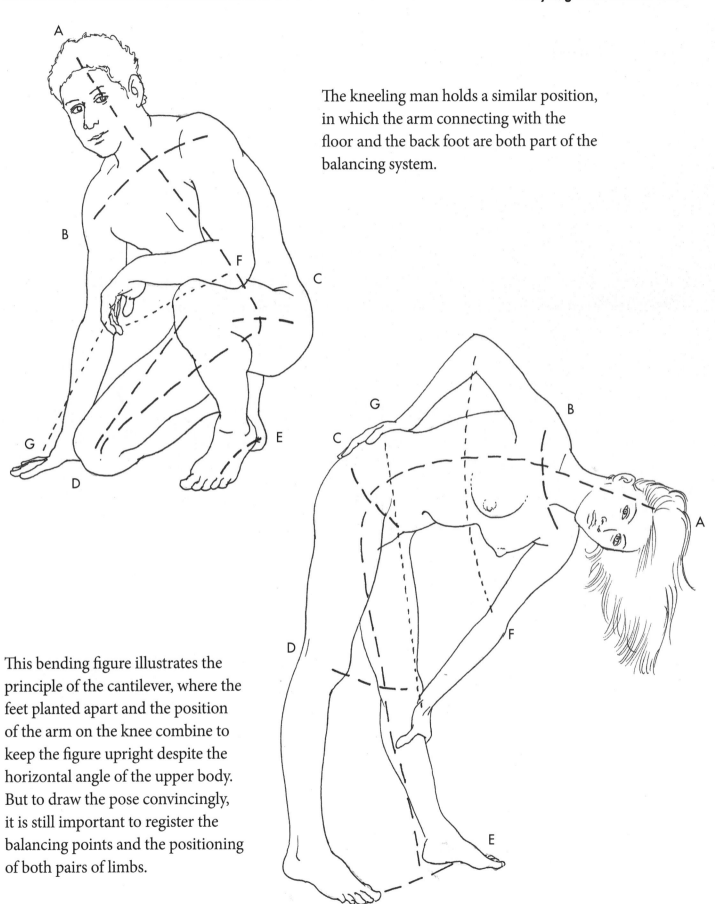

The kneeling man holds a similar position, in which the arm connecting with the floor and the back foot are both part of the balancing system.

This bending figure illustrates the principle of the cantilever, where the feet planted apart and the position of the arm on the knee combine to keep the figure upright despite the horizontal angle of the upper body. But to draw the pose convincingly, it is still important to register the balancing points and the positioning of both pairs of limbs.

///// Body Details

Studying each part of the body separately willl contribute to your knowledge of the figure as a whole and will help enormously when you are drawing from life.

Torso

If your figure drawing is to be correct, you need to understand something of the largest part of the human body, the torso or trunk. This is the area from the shoulders down to the pubes, ignoring the head, arms and legs. Compare these back and side views of the male and female torso. Once you understand the effect of these differences, you should find it easier to draw either of the sexes.

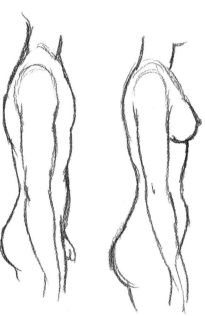

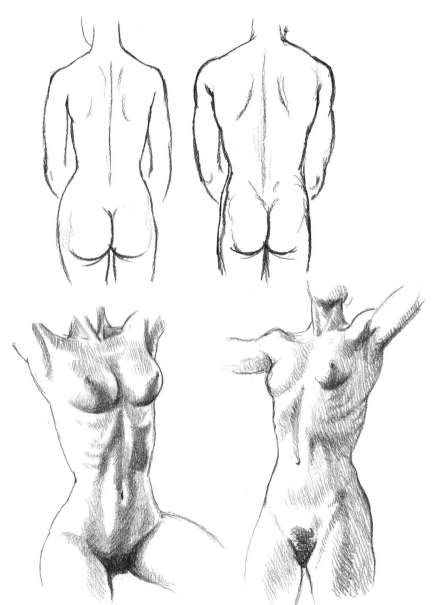

To the left and at the top of the next page we have a few studies of the female torso. Notice the way the ribcage shapes the upper torso and how the figure can bend and twist in the middle because the pelvis and the ribcage are not held rigidly by the spinal column. Note that the muscles of the back and the diaphragm are distinct.

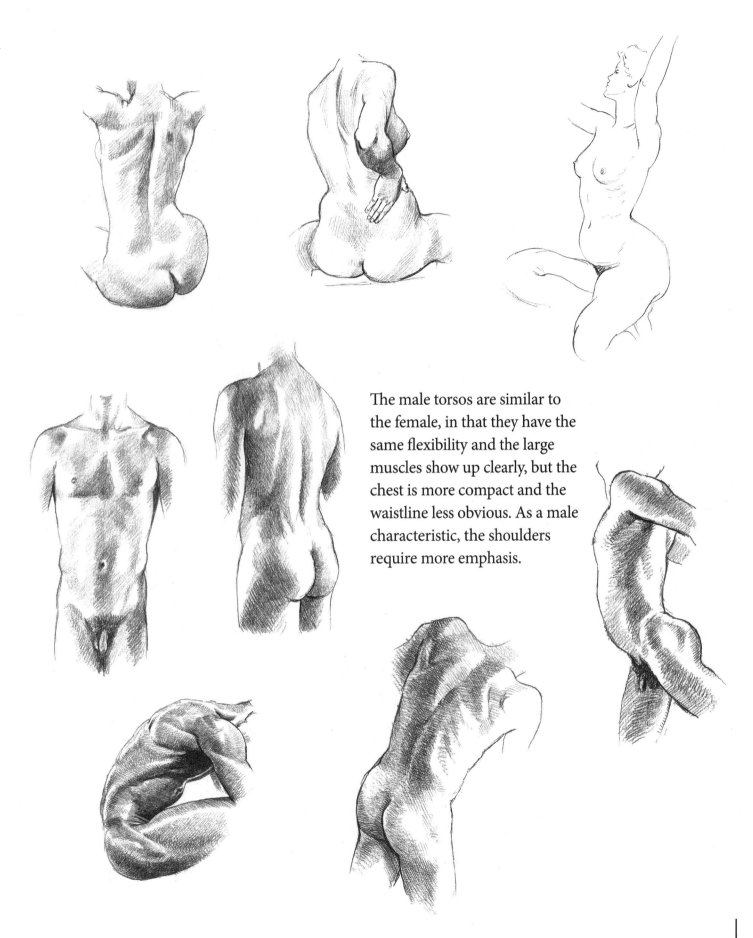

The male torsos are similar to the female, in that they have the same flexibility and the large muscles show up clearly, but the chest is more compact and the waistline less obvious. As a male characteristic, the shoulders require more emphasis.

Arms and Hands

Elbows and wrists are extremely important features but are often poorly observed by students. By paying extra attention to these joints when you are drawing the arms you will enormously increase the effectiveness of your drawing.

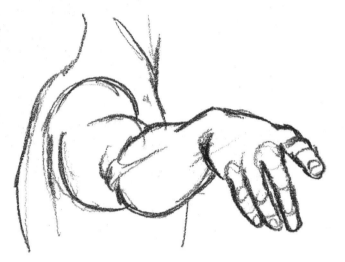

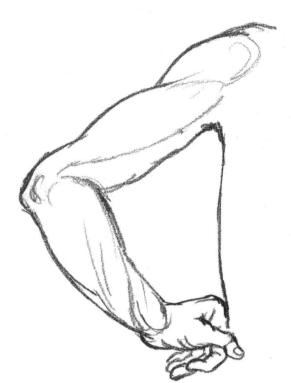

You can see from this drawing how the arm provides a background to the expressions or actions of the hand.

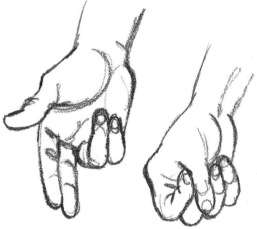

The thumb demands separate treatment, so spend some time practising drawing its characteristic angle. Note how in poses the thumb helps to define the direction in which the hand is pointing.

With the arms akimbo, the gently folded hand reduces the aggressive quality of the pose.

The hand is an extremely effective means of conveying emotional and instinctive gestures. As well as providing a focal point, the outstretched arm or hand often provides an important key to a picture.

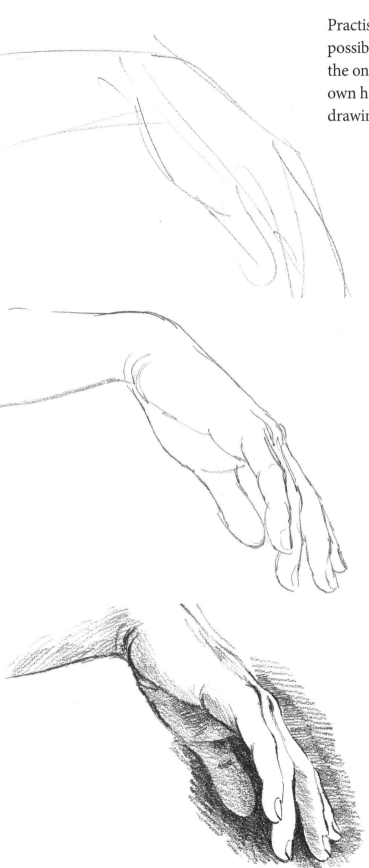

Practise drawing hands very simply from all possible angles. Start with an easy angle, such as the one shown here. You can do a lot with your own hands by using a mirror, or you can try drawing someone else's hands.

1. Sketch out first the main lines, the direction in which the fingers point and the basic proportions of fingers to palm, finger joints and the relative spacing of joints on fingers.

2. Once you are sure these lines are correct, fill out the shape.

3. Finish off by adding tonal values.

Feet and legs

It is worth making something of a feature of feet because the viewer's attention nearly always goes to the extremities of objects; thus the hands, feet and head are noticed in a drawing.

Feet are not as difficult to draw as hands, but they can be tricky from some angles and this can result in awkwardness in your drawing. It's a good idea to practise drawing them from the front, back and both sides. To begin with, try drawing your own feet in a mirror. Feet do differ quite a lot and rarely conform to the classical model. Look at these examples, taking note of the major characteristics.

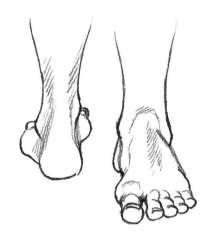

In these views you can see that the inner ankle bone is higher than the outer ankle bone. Looking from the back, note the ball of the heel and the Achilles tendon. From the front, notice how the line fluctuates to take in the large toe, the instep and the heel.

Note the proportions of the toes in relation to one another and in relation to the whole length of the foot.

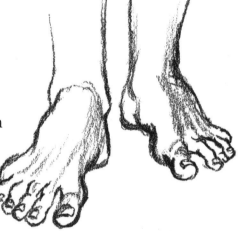

From this angle the large toe partly obscures the smaller toes. Note the instep and arch of the foot.

An outside view shows the flatter part of the sole and the toes more clearly.

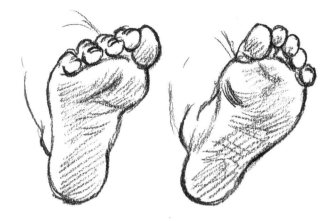

You will need to know how to draw the feet from below, although it is probably not a view that you will use often. The relationship of the toes to the sole is very different from this perspective.

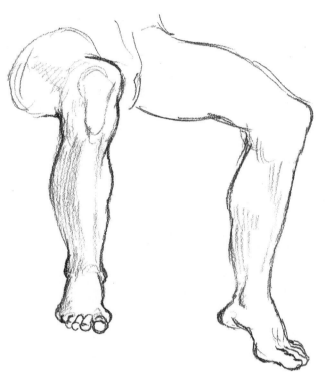

The knee is a complex joint that you should study closely because of its importance in the structure of the leg. It is, in fact, a rather interesting shape and can be fascinating to draw when the knee-cap is clearly defined, as here.

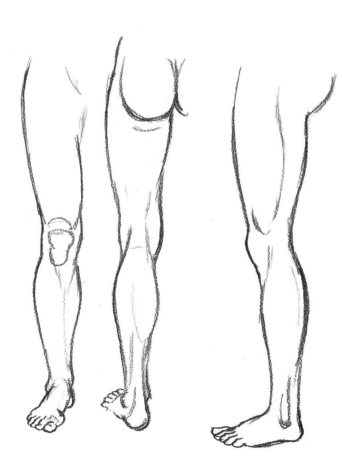

The shape of the leg is determined by how well the muscles are developed. In these drawings all the leg muscles are clearly delineated.

The joining of the leg to the foot can prove problematical for the novice. Pay particular attention to the relationship of the ankle to the instep and practise drawing this.

Drawing Movement

Drawing a figure in motion is not easy but at some point you should take the plunge and have a go at it. Instructing your model to keep repeating the same movement is one approach that works very well. While this performance is going on, you should try to capture each phase of the sequence and sketch it as well as you can. If the movement is repeated often enough, it is possible to keep returning to a certain position and take another look at how to draw it.

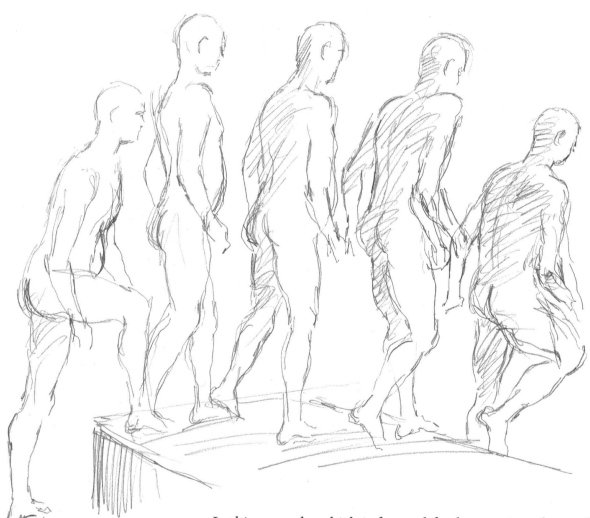

In this example, which is from a life-class session, the model walked across a dais over and over again, trying to keep the action the same each time. You could enlist the help of friends for this, if you were to choose some simple movement to begin with. Even if early attempts don't look too good, persevere with practising whenever you can and you will find that your 'motion drawing' will improve.

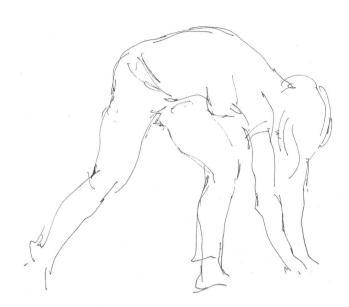

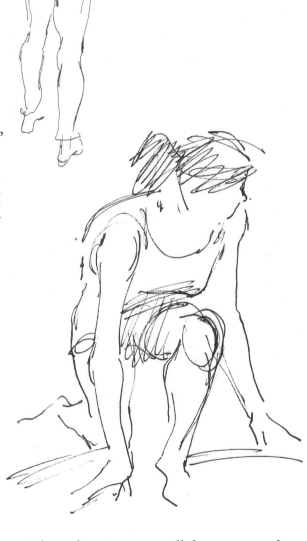

Catching the fleeting gesture

Once you have begun experimenting with action drawing, set yourself up in a place where you can view plenty of people walking about and see how many quick sketches you can get down. If that is not so easy for you, try getting a friend to move around slowly and draw as many of their changes of position as you can.

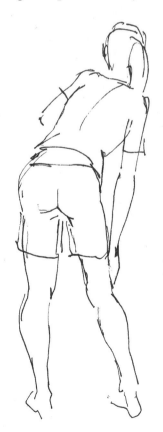

These drawings were all done extremely quickly, with the same model moving around and performing very simple, ordinary movements. Don't struggle to be too accurate and remember that the more you do this the easier it gets.

The Body in Motion

These drawings show in more detail what happens to the body when it turns, bends or stretches. Note these changes for yourself, then copy the drawings, concentrating on the most obvious shapes.

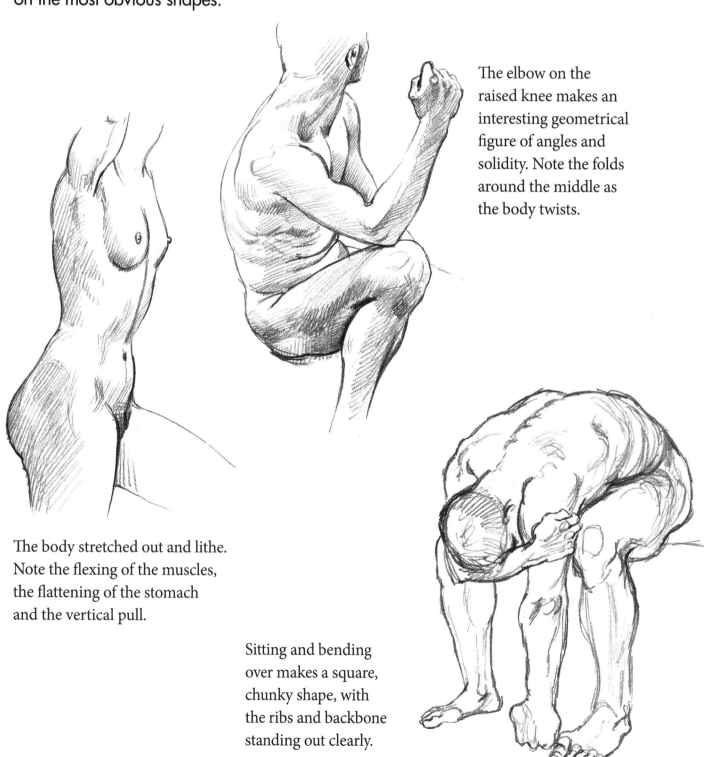

The elbow on the raised knee makes an interesting geometrical figure of angles and solidity. Note the folds around the middle as the body twists.

The body stretched out and lithe. Note the flexing of the muscles, the flattening of the stomach and the vertical pull.

Sitting and bending over makes a square, chunky shape, with the ribs and backbone standing out clearly.

When you draw a moving figure it pays to try the movement for yourself so that you can 'feel' it from the inside. Even if you don't actually perform the same movement, imagine what it would feel like. Actually feeling what you are drawing will help you to bring expression to your work and make it more convincing.

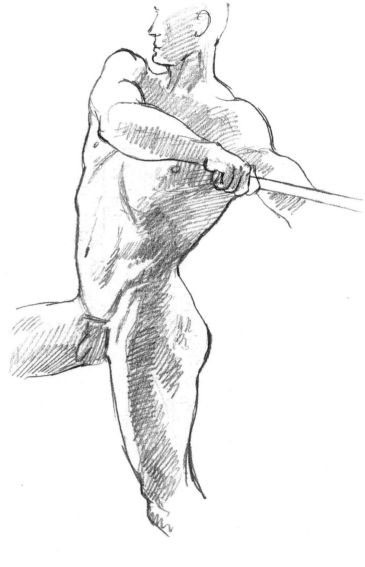

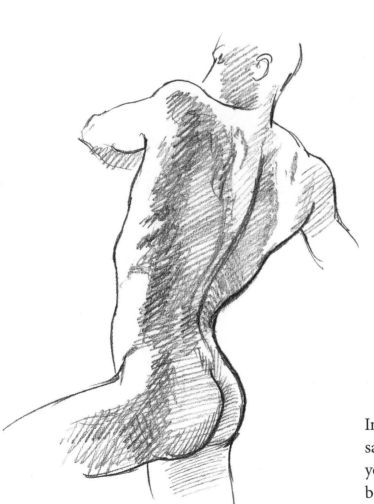

In these two drawings the figure is seen making the same movement from different angles. This enables you to 'see through' the figure and understand better what is happening to the body. Such understanding makes drawing easier.

////// Styles and Techniques

Pencil: Precision

The pencil is perhaps the most versatile of all the media, allowing you to roughly sketch figures or to render them in great detail, as in the example shown here.

This meticulous pencil drawing, by the German Julius Schnorr von Carolsfeld (1794–1872), is one of the most perfect drawings in this style I've ever seen. The result is quite stupendous, even though this is just a copy and probably doesn't have the precision of the original. Every line is visible. The tonal shading which follows the contours of the limbs is exquisitely observed. This is not at all easy to do and getting the repeated marks to line up correctly requires great discipline. It is worth practising this kind of drawing because it will increase your skill at manipulating the pencil and test your ability to concentrate.

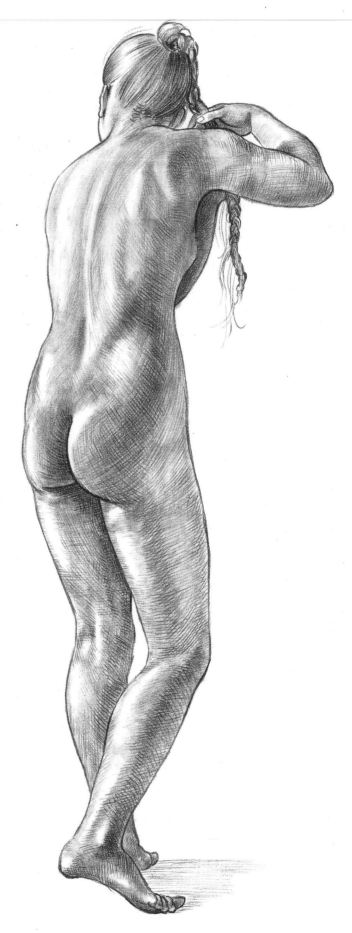

Pen and Ink

Pen and ink is special in that once you've put the line down it is indelible and cannot be erased. This really puts the artist on his mettle because, unless he can use a mass of fine lines to build a form, he has to get the lines 'right' first time. Either way can work. Once you get a taste for using ink, it can be very addictive. The tension of knowing that you can't change what you have done in a drawing is challenging.

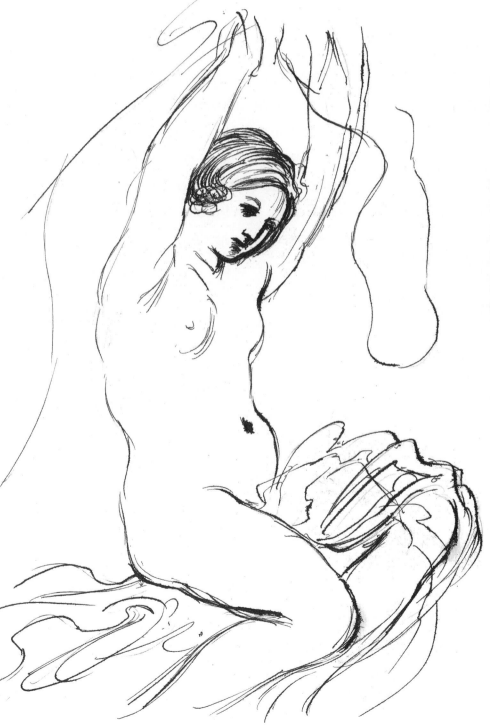

Rarely have I seen such brilliant line drawings in ink of the human figure as those of the painter Guercino (1591–1666). In this example the line is extremely economical and looks as though it has been drawn from life very rapidly. The flowing lines seem to produce the effect of a solid body in space, but they also have a marvellous lyrical quality of their own. Try drawing like this quickly, without worrying about anything except the most significant details, getting the feel of the subject in as few lines as possible. You will have to draw something directly from life in order to get an understanding of how this technique works.

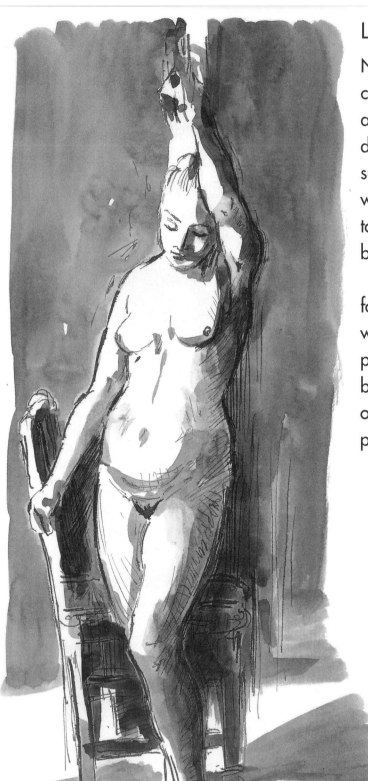

Line and Wash

Now we move on to look at the effects that can be obtained by using a mixture of pen and brush with ink. The lines are usually drawn first to get the main shape of the subject in, then a brush loaded with ink and water is used to float across certain areas to suggest shadow and fill in most of the background to give depth.

A good-quality solid paper is necessary for this type of drawing; try either a watercolour paper or a very heavy cartridge paper. The wateriness of the tones needs to be calculated to the area to be covered. In other words, don't make it so wet that the paper takes ages to dry.

This drawing after Rembrandt (1606–1669) is very dramatic in its use of light and shade.

Chalk

The French neo-classicist master Pierre-Paul Prud'hon (1758–1823) was a brilliant worker in the medium of chalk on toned paper, manipulating light and dark tones to suggest form.

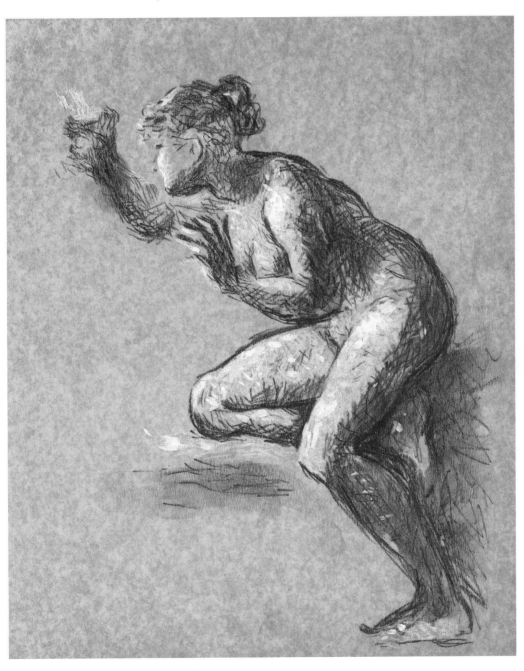

In this drawing of Psyche, marks have been made with dark and light chalk, creating a feeling for light which is rather Impressionistic in flavour. The lines, which are mostly quite short, go in all directions. The sense created is of a figure in the dark. This is helped by the medium tone of the paper, which almost disappears under the defined mark making.

Reclining nude

I would now like to show you some of the finest studies ever made of the human figure and they are all on one particular theme. Since the Renaissance, the female nude has been a favourite subject for artists and here is a selection for comparison.

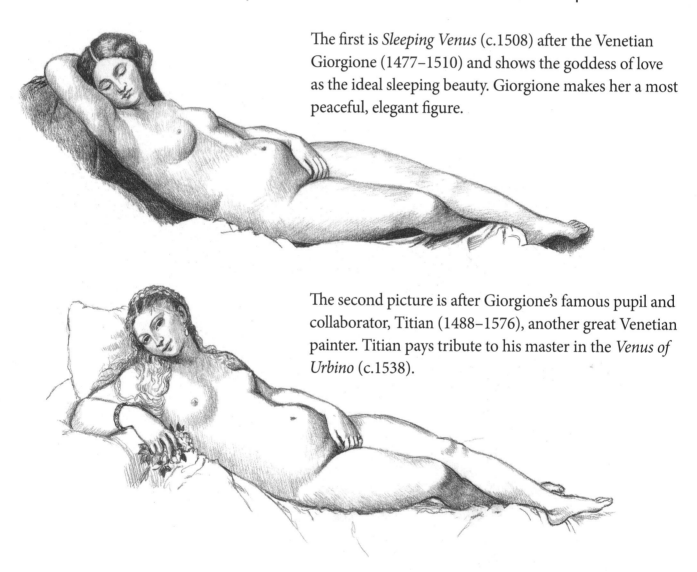

The first is *Sleeping Venus* (c.1508) after the Venetian Giorgione (1477–1510) and shows the goddess of love as the ideal sleeping beauty. Giorgione makes her a most peaceful, elegant figure.

The second picture is after Giorgione's famous pupil and collaborator, Titian (1488–1576), another great Venetian painter. Titian pays tribute to his master in the *Venus of Urbino* (c.1538).

He closely follows Giorgione's pose, but on this occasion the beauty is wide awake and looking directly at us. For the time this was very unusual because the female nude normally posed modestly with downcast eyes. But Titian was no ordinary painter and he draws us in with the element of seduction in this portrayal of his Venus.

The next study, the *Naked Maja* (1799–1800) after the Spanish master Francisco Goya (1746–1828), is in the 18th-century tradition of the bacchante or nymph, gazing out of the picture at us, relaxed and at ease on her couch, demanding that we appreciate her charms. But there is an indication that the subject of this picture is not quite as decorous as she should be. This is definitely a challenging portrait, and one that was painted for a notorious libertine at the Spanish court, Manuel Godoy.

The last of these 'grand horizontals' is *Olympia* (1863), the portrait of a Parisian courtesan painted by Edouard Manet (1832–83). This pays homage to Titian's *Venus of Urbino* but Manet places the young woman in a more challenging pose. Manet was the subject of much criticism when he showed this picture because he didn't try to conceal the girl's lifestyle under the guise of a goddess or nymph. This meant that he was challenging the Parisian art critics to recognize that real life was as much the stuff of art as any mythological subject matter.

The interesting thing about all these pictures is that although each one may be a straightforward nude, in reality it represents a whole new way of looking at life and art. Don't worry that any pose you might choose has been attempted before: it is what you do with the standard human figure in a particular situation that will make your drawing significant or not.

//// Practice: the 'Rokeby Venus'

Here you can see another master painting, the *Rokeby Venus* by Diego Velásquez (1599–1660), which shows another reclining female nude but this time from behind. Try following the steps to make your own copy, paying attention to the direction of the light source as this will tell you what is happening to the shape of the body.

1. Sketch in the main outline, ensuring that the proportions are correct. Note the lines of the backbone, shoulders and hips. Check the body width in relation to the length and the size of the head in relation to the body length. Pay special attention also to the thickness of the neck, wrists, ankles and knees. All of them should be narrower than the parts either side of them.

2. Finalize the shape of the limbs, torso and head. Then draw in the shapes of muscles and identify the main areas of tone or shadow.

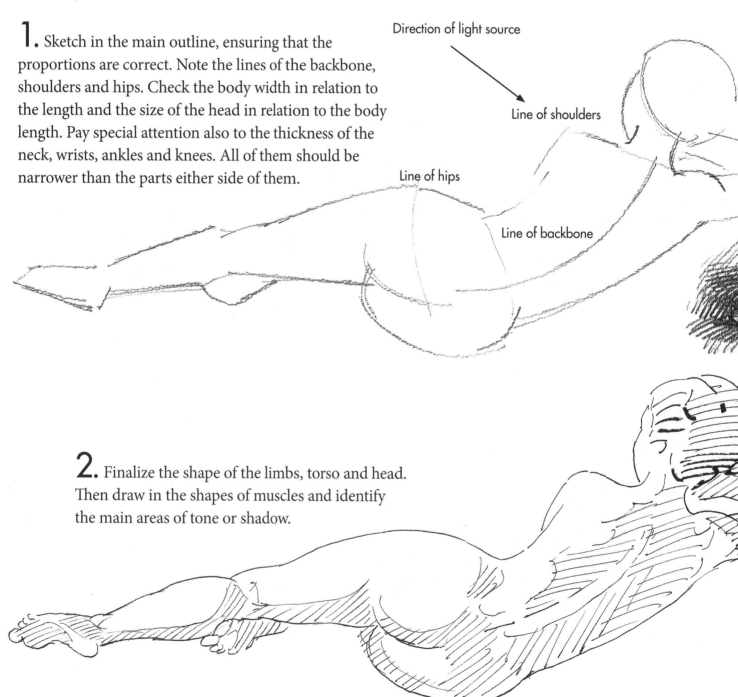

Direction of light source

Line of shoulders

Line of hips

Line of backbone

Keep everything very simple to start with and don't concern yourself with producing a 'beautiful' drawing. Really beautiful drawings express the truth of what you see.

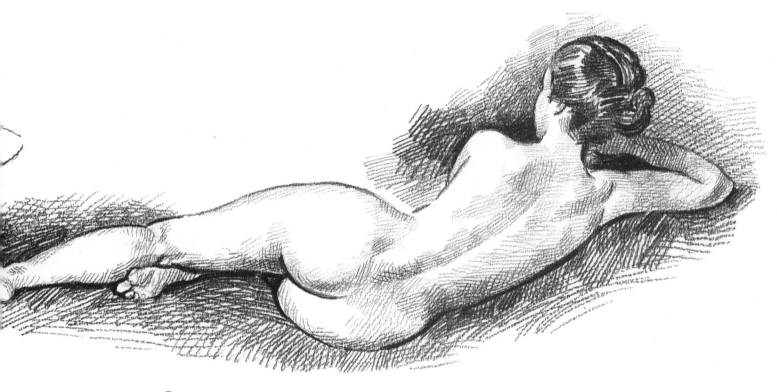

3. Carefully model in darker and lighter tones to show the form. Some areas are very dark, usually those of deepest recession. The highlights or very light areas are the surfaces facing directly towards the source of light and should look extremely bright in contrast to any other area.

When you have finished applying tone, give your figure a place to exist in by adding tones to the background. These will enhance your drawing by throwing the strongly defined areas of light forwards, thereby increasing the three-dimensional effect.

Index

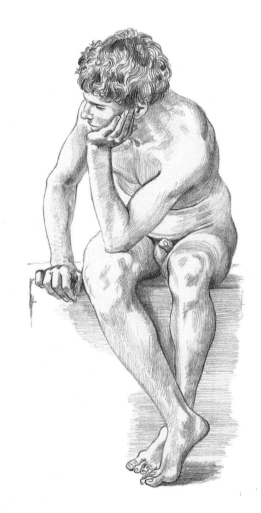